T0155461

3X3

A Post-It Note Collection

Vol. 1

Kennon James

3X3: A POST-IT NOTE COLLECTION VOLUME ONE

Published by Outland Entertainment LLC
3119 Gillham Road
Kansas City, MO 64109

Publisher: Jeremy D. Mohler
Editor-in-Chief: Alana Joli Abbott
Chief Creative Officer: Anton Kromoff

ISBN: 978-1-954255-77-7

Worldwide Rights

Created in the United States of America

Writing, Artwork & Cover Design: Kennon James
Interior Layout: Jeremy D. Mohler

Printed and bound in China.

Visit outlandentertainment.com to see more, or follow us on our Facebook Page facebook.com/outlandentertainment/

For Jolene, Aiden, Avery & Cypress

A Special Thank You To:
Nathan James, Dylan Swank, Steve Dunne, John Popson, Tre Manor, Jeremy Mohler, Alex Bates, Angela De La Rosa, Christina Hernandez, Magnus Eriksson, Raven Perez, Patrick Burch, Chet Minton, Rob Wheeler, Eric Talbot, Robert Lockhart, Thomas Perkins, Anthony & Kailey Diaz, Debbie Perales, Richard Garcia, Tom Kent, Lyn Orzech, Patton Davis, Joe Kushner, Moriah & Ron Chandler, Ragan Bourgeois, Chris Edrington, Chuck Whelon, Justin McCoy, Rick Hershey, Chris Walker, Robert Rapier, Patton Davis, Wes Amann, Suzanne Wieringo, Alex Wilbur, Kosta Ketsilis, Aaron Sacco, Christopher Jennings, Kevin Peake, Mike Churchill, Sean Cason, Ben Boling, Matt Hildebrand, Brian Stillman, Jeremy C. Joseph, Steph Swope, Craig Staggs, Chris Arneson, Shannon Portratz, Mike Manley, Jamar Nicholas, Steve Conley, Travis Hanson, Benjamin Rodman, Greg Gillespie, Drew Day Williams, Row Cowing, Yael Sanchez, Mark Davis, McLain McGuire, Mike Chapel, Gale Murrin, Dave Gray, Michelle West Sansil, Dave Madden, John Booth, The HUGBROs, Outland Entertainment, and all the awesome Kickstarter Backers that made this book a reality.

WHY POST-IT NOTES?

Almost ten years ago, I found myself, like so many who chose to enter corporate life, in a meeting. In that meeting there were lots of people talking about things that generally had nothing to do with me or my job, but there were lots of Post-It notes laying around. So I did what many people do in that scenario - I started scribbling. Aimless scribbling became focused drawing and soon it became something I genuinely enjoyed doing (the drawings, not the meetings). The small size, spontaneity, and the ability to start and quickly finish made it liberating and fun.

After leaving the corporate life behind, I continued doing Post-It notes occasionally - to warm up, jot down an idea, or do roughs for paying gigs. The 3"x3" format had become a familiar and comfortable workspace.

Every year, I participate in Inktoberfest, a month-long challenge to improve inking skills and develop positive drawing habits. During that month, a daily prompt word (indicated in this book by bold type) is provided as an optional keystone. Over several years of participating in Inktober, I found that Post-It notes offered a perfectly efficient canvas, as their small size prevented me from becoming overly ambitious. Before long, I found that I had close to a hundred of them, and this fun little exercise had given me a sizable body of work that was languishing on a shelf inside a sketchbook. So I decided to collect my favorites into a book.

This is that book.

--Kennon, 2023

TEETH

5.15.2015

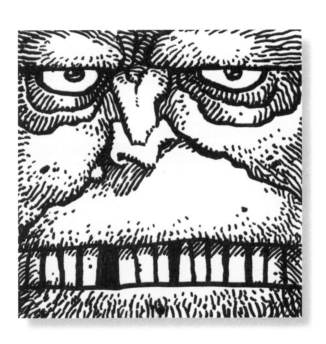

GLASSES

5.7.2015

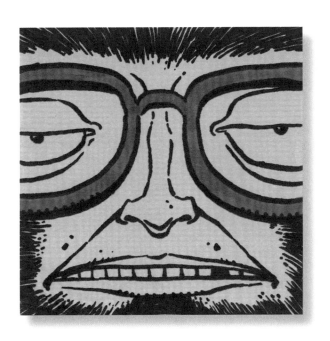

MODOK

5.8.2015

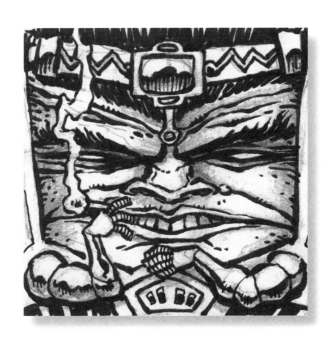

IMMORTAN JOE

5.21.2015

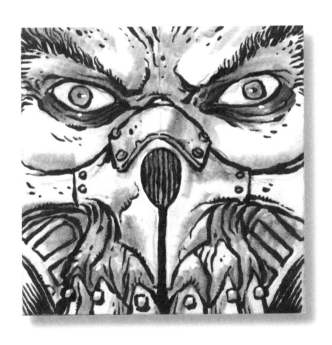

DWARF FACE

10.16.2015

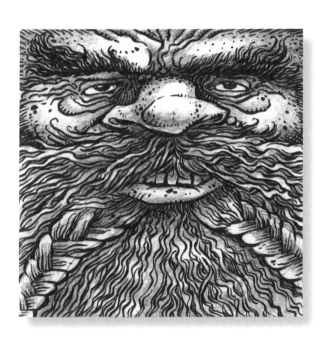

CREATURE FROM THE BLACK LAGOON

10.26.2015

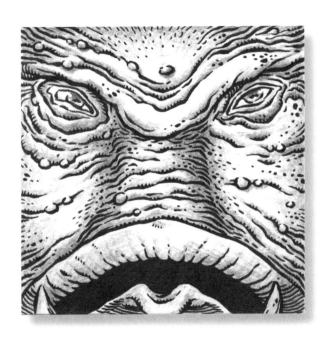

CTHULHU VISIT

10.26.2015

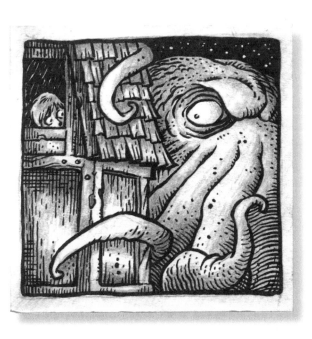

BRAAAINS...

10.27.2015

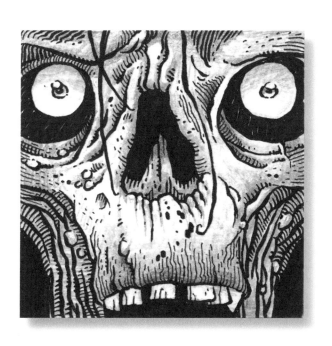

Bert finally realized his steampunk Halloween
costume would never be complete without goggles.

BERT THE BEHOLDER

10.28.2015

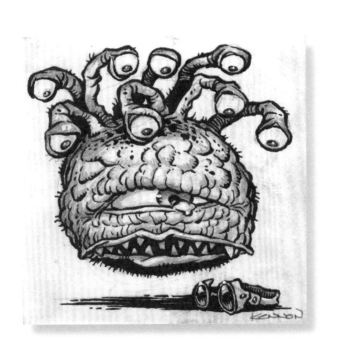

LOVECRAFT & TENTACLES

10.1.2017

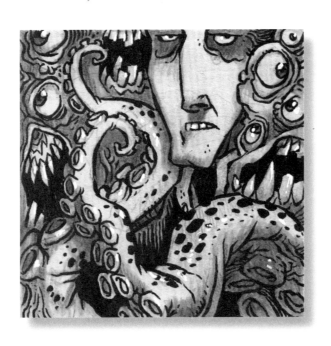

HEAVY METAL HAT

10.2.2017

WOLVIE

10.5.2015

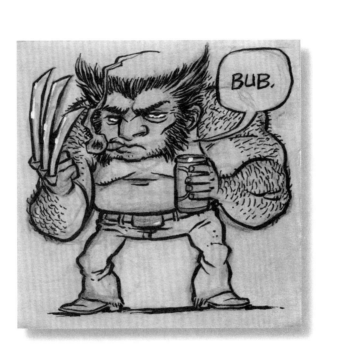

SILLY SATURDAY DINOSAUR

10.7.2017

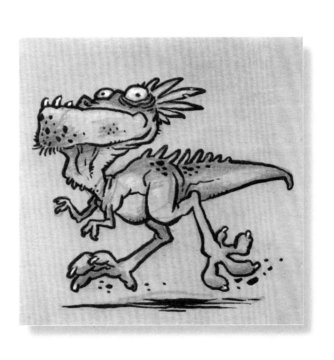

OGRE BIRD

10.8.2017

HELLBOY 01

10.10.2017

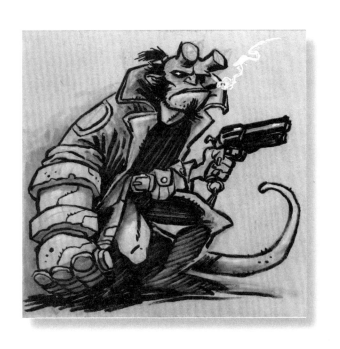

GNOMISH CAVALRY

10.12.2017

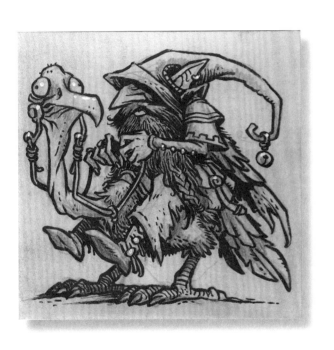

WAITING ON A PRINCE

10.17.2017

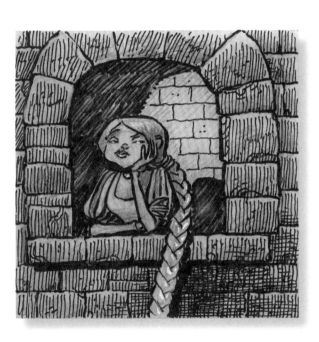

In the grim future of the apocalyptic wasteland
there are only Post-it note drawings of Furiosa.

FURIOSA 01

10.23.2017

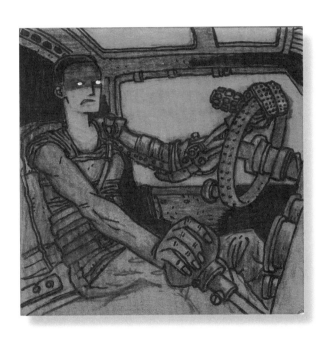

STEGOSAURUS NEED LOVE TOO

8.29.2018

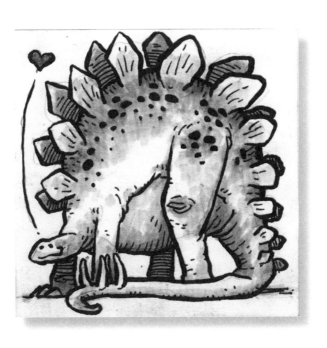

CTHULHU UNDERWATER

9.3.2018

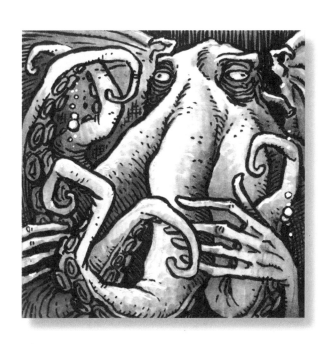

Generally, being a whale was pretty cool but sometimes Bernhardt longed for a good cigar.

WHALE IN HAT

10.12.2018

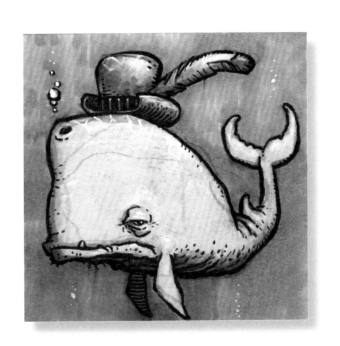

Beatrice grew tired of her rounded life. She longed for an **angular** one.

BEATRICE THE BEHOLDER

10.16.18

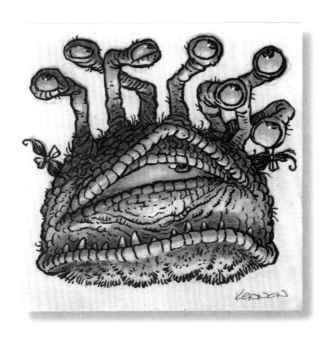

Gilbert was once puny and picked on by all the other goblins. One afternoon while he was reading his comic books he saw an ad that made him decide to make a change. After lots of hard work and a strict diet of broccoli and steamed elf (white meat only), Gilbert got **swollen**. Now he's the one doing the picking.

GILBERT THE GOBLIN

10.17.2018

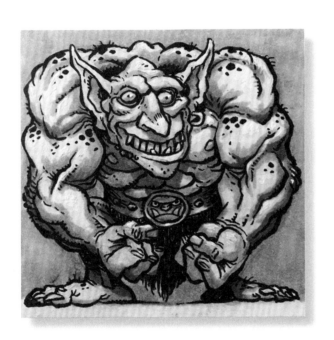

In the apocalyptic future our robotic overlords will search the **scorched** earth for remants of the human race riding happy dinosaurs.

ROBOT RIDING DINO

10.19.2018

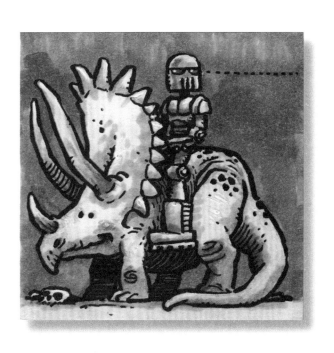

HELLBOY 02

10.23.2018

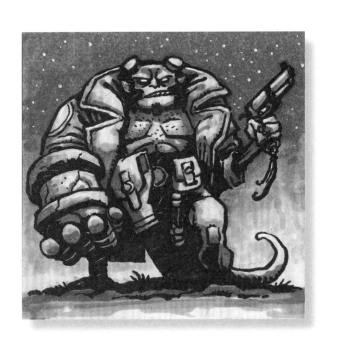

There's prickly, then there's Wolvie standing in a cactus patch **prickly**.

WOLVIE 02

10.24.2018

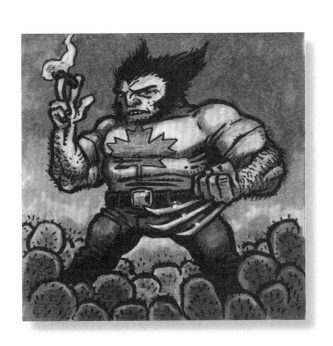

Orc tax laws were simple (even by orcish standards) and easily manipulated but Matilda Dwarf-mangler thought that claiming goblin benefits (even though her great-great-grandmother on her mother's side was a goblin) was a bit of a **stretch**.

ORC TAX LAWS

10.26.2018

POCKET BATMAN
10.30.2018

BEASTMAN

2.18.2019

XENO FISH

3.31.2019

WASTELAND CAR

10.16.2019

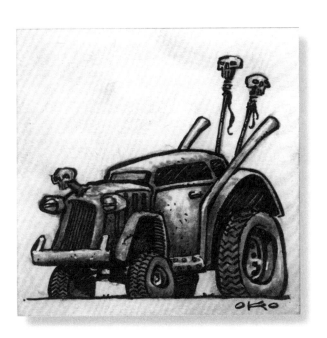

MICHELANGELO

6.10.2020

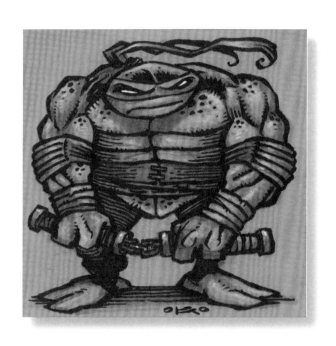

"They were the blasphemous **fish** frogs of the nameless design - living and horrible." - The Shadow Over Innsmouth, H.P. Lovecraft

FISH FROGS

10.2.2020

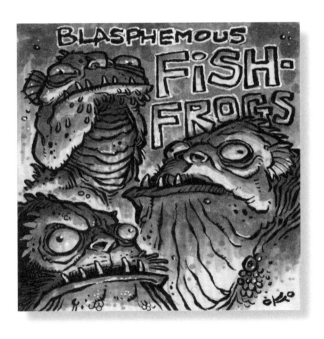

After a long day of slaying goblins and evil wizards, Wilamina liked to unwind with her favorite pipe. For hours, only a **wisp** of smoke and an occasional trollish chuckle would tell of her presence at the back of the inn.

WILAMINA

10.4.2020

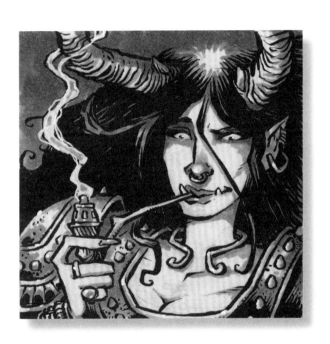

Although the helmet and armor were kind of **bulky**, Little Renlo wanted to be like Dad so he rode hard every day.

BIKER SCOUT

10.5.2020

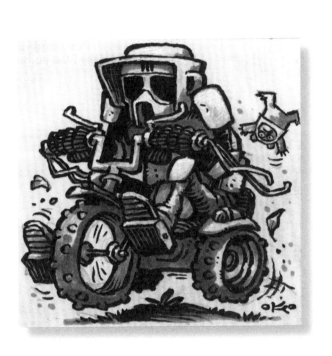

Despite having a natural affinity for the **radio**, Bobo's favorite thing about space flight was the banana ice cream (and the diapers).

SPACE CHIMP

10.6.2020

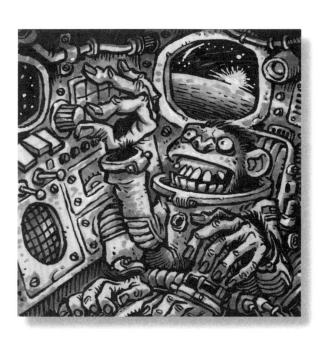

Although being a cleric forbade him from bran-
dishing a sword, one look at the fabled **blade**
"Skullhammer" made Brother Mynerd seriously
consider a career change.

SKULLHAMMER

10.7.2020

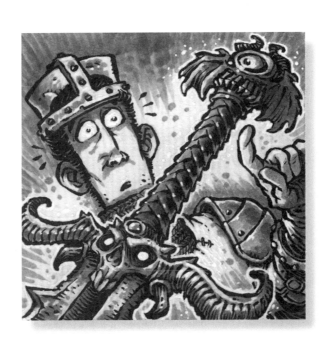

All-You-Can-Eat Owlbear Legs at The Tongue of Dung Tavern was his favorite night of the week, but the best part for Gorgak was the **fancy** ketchup.

OWLBEAR LEGS

10.15.2020

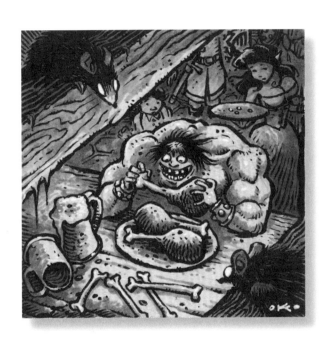

The Jedi gave him a really bad feeling and made his **teeth** click. But knowing the fat guy, he wouldn't heed Bib's remonstrances anyway.

BIB

10.16.2020

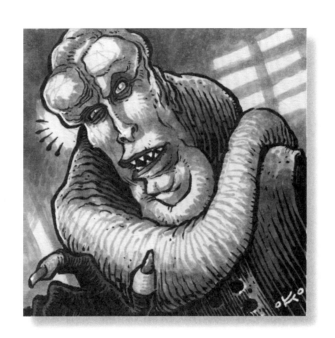

After he learned how to **throw** a fireball, Bawl-skag's barbecues were not to be missed.

FIREBALL!

10.17.2020

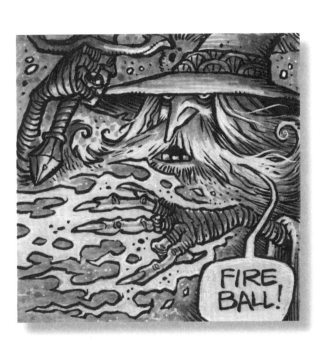

She knew grabbing the breeders was a long shot, but her **hope** was that Joe would be sufficiently distracted and not miss their absence until they were well on their way.

FURIOSA 02

10.20.20

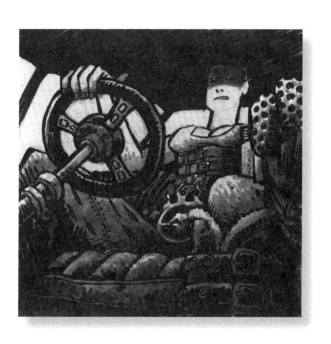

After serving in the army of His Most Repulsive One, Nurgle, God of Pestilence and Disease for many years, his quarterly review was once again coming up and Noxiousicus knew if he got high marks again for being "extremely vile and utterly **disgusting**" by his supervisor it might mean a pay raise and maybe even, finally, being promoted to "Senior Chaos Warrior." The missus would be pleased.

PLAGUE GUY

10.22.2020

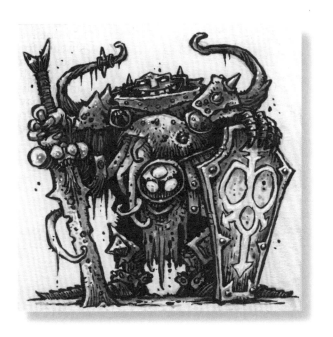

SANTA

10.23.2020

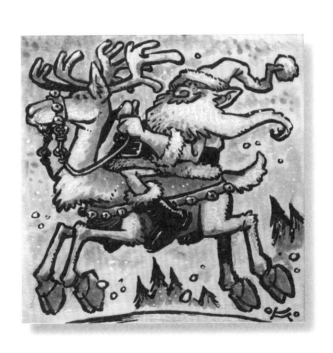

HELLBOY 03

1.31.2021

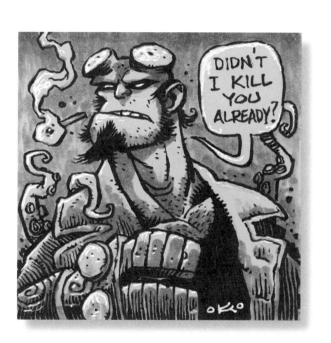

XENO

6.16.2021

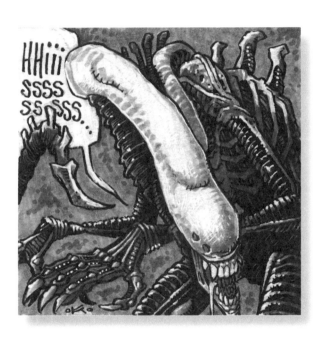

CTHULHU FHTAGN!

6.28.2021

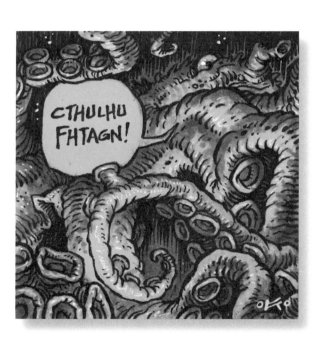

After receiving Stogan's raven summoning him to rendezvous with the rest of the party at the Trampled Donkey in Deepwater, Carnath set out, confident he had everything he needed to help storm the Crimson Tower of the Moon Goddess, until he realized he may have left the coffee pot on.

COFFEE POT

8.4.2021

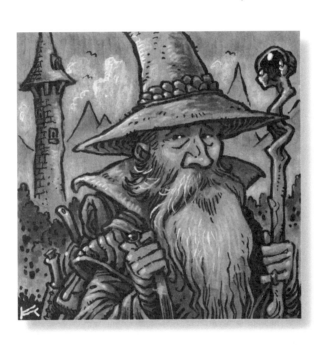

Despite the warnings from the blind sage, and his own sense of foreboding, Burgerid carried the **Crystal** Staff of Akk. It was always in the deepest parts of the dungeon that it really gave him the creeps.

CRYSTAL STAFF

10.1.2021

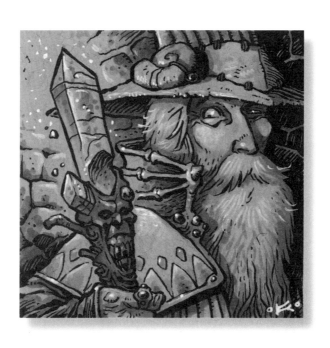

DRAGON RIDER

10.7.2021

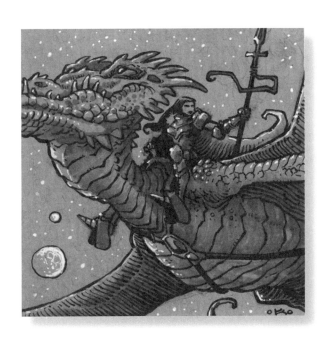

DRAW!

2.18.2022

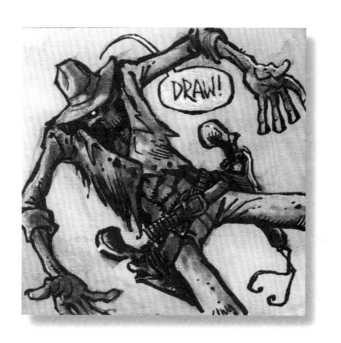

While planning his overthrow of the peaceful town of Chalice, Black Thom would often sit on his favorite chair with his favorite pipe and go over tomorrow's gameplan of evil and mayhem.

BLACK THOM

3.2.2022

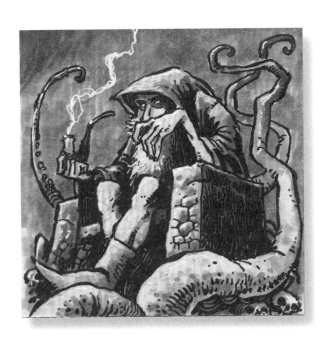

After the thrashing they took in the ruined throne room, and the loss of Elvarine (Gelm told her not to step there), the four regrouped at the Ol' Bawdy Cat to discuss their next move. And even though his logic was sound, Althenis' suggestion to take the secret passage to avoid the kobolds, but consequently desecrate the burial mound of the Great King of Noemann, was not well received.

PARTY PLANNING

3.3.2022

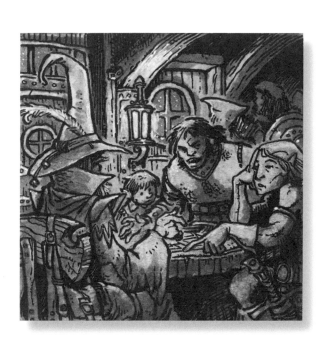

Althenis had warned him, but the swamp troll's lair, and the treasure contained therein, was too much for Bombil to resist. And now his decision to trade his Potion of Wisdom for the Ring of Bog-walking seemed like a really bad idea.

HIDING PLACE

4.7.2022

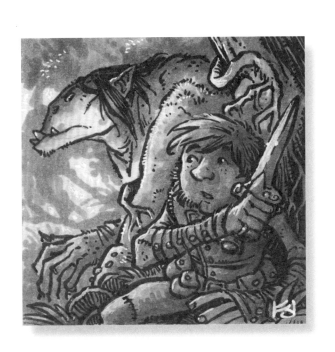

True to form, the goblins routed, exposing the army's left flank. She still had the orc spearmen in reserve, of course, and the battle would be easily won. But it was days like this that really made Belrudred the Bloodrobed regret not taking her grandpappy's advice to go into real estate.

BELRUDRED

4.14.2022

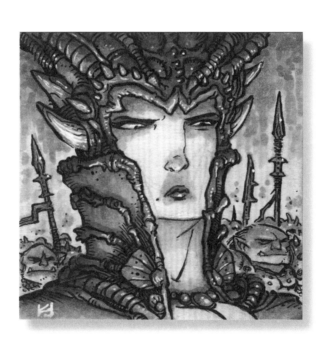

BOAR BOY

9.26.2022

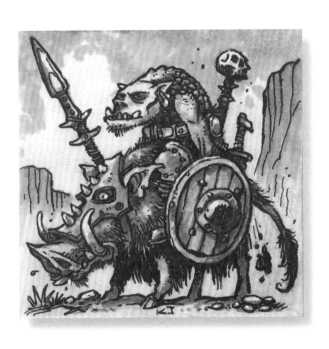

Breaking into the temple was easy enough for Timonn, but sneaking past the **gargoyle** on the roof was the worst.

GARGOYLE

10.1.2022

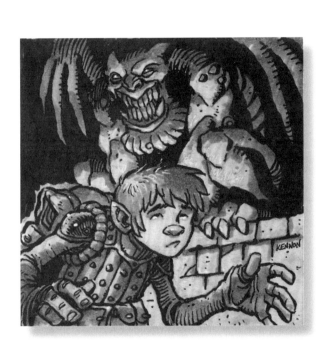

All the other wizards laughed when Shady Steev spent his last crown on the "giant cockroach egg." But now, as he and Skrittch **scurry** to spell-book club every week, none of them are laughing anymore.

SHADY STEEV

10.2.2022

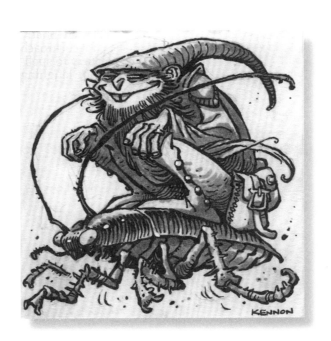

That's always the problem with summoning **bat** demons - you never know how big they're going to be.

BAT DEMONS

10.3.2022

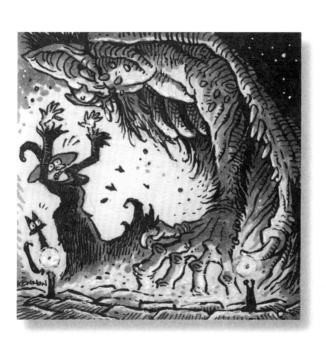

Under the light of the second moon, Cormac's weary gaze fell upon the entrance to the Cave of Souls, marked by the stone **scallop**, as the sea witch had foretold. By all legends, those inky depths held vast treasures, and the Pearl of Shadows. The deposed king would reward him well.

HIDDEN CAVE

10.4.2022

After the long road from the battle of Harrengil, there was just one thing that would lift Arenfar's dark spirits. But when his torch **flame** fell upon the battered closed sign he knew his dreams of Rumelda Proudfeet's House of Pies would have to wait until tomorrow.

FLAME

10.5.2022

He brought his typical back-to-goblin-school list with the usual stuff on it; 50' of rope, one bottle of semi-sweet mead, a couple of sparrows (dead or alive), one chest of unspecified gunk, one caged dragoncrow, one single-bladed axe (slightly sharp), one box of crayons, etc... but Gutslik thought he'd really go above and beyond with a **bouquet** of flowers (recently stolen of course) to really catch that warchief's eye.

GOBLIN BACKPACK

10.6.2022

He thought he was the lucky one when he found the old van in an abandoned garage on the reservation. But when the space whales showed up Steve realized the truth - this was the bad **trip** the shaman had warned him about.

SPACE WHALES

10.7.2022

He thought the villagers' tales were deliberately over-exaggerated to scare children and wandering souls away from the burial mounds. But when Azbad laid eyes on the beast he knew, to his dismay, that he was no **match**.

SWAMP BEAST

10.10.2022

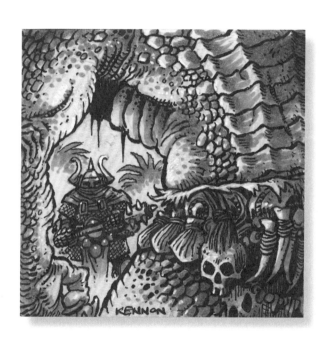

Cockatrice **nest** hunting always attracted the most dangerous predators, but those epic omelettes made it absolutely worth it.

COCATRICE OMELETTES

10.11.2022

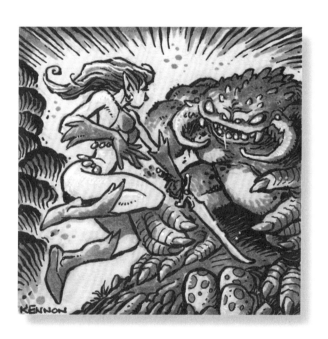

Every full moon it was the same old jazz: Mildred would bring the sage, Dorothy would bring the moon flowers, Marie would bring the candles, and Ruby would bring her big dumb cat; but no one would ever remember to bring the right spellbook. The whole thing made her nothing but **crabby**, so Jolene grabbed her jack-o-lantern and went home.

BAH!

10.13.2022

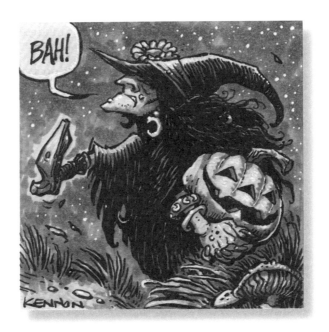

The dust on Adama IX made a mess of the ARV's (Astro Roving Vehicle) tracks and exhausts, making them completely unusable. But the taming of the indigenous giant **armadillo** population was a timely stroke of luck.

SPACE ARMADILLOS

10.18.2022

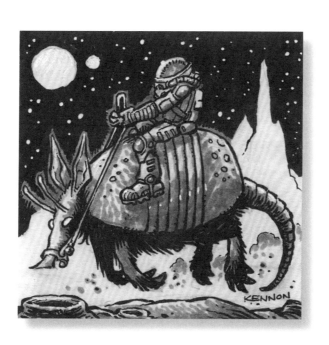

Kennon enjoys playing board games and writing about himself in third person while waiting for football season to start. He lives in the massive megalopolis of Hutto, Texas with his wife, kids, dogs, cats, and fish.